Updated for CC 2019

Speaking Photoshop CC Workbook

David Bate

Bate Publishing Milwaukee

▲ PREFACE ▼

Speaking Photoshop CC Workbook • David Bate

Bate Publishing
18745 Ridgewood Lane
Brookfield, Wisconsin 53045
DBate@SpeakingPhotoshop.com

Editors
Rick Bate
Mary Bath
Bill Elliott
Robert Manak

Contributors
Phyllis Bankier
Rick Bate
Bill Elliott
Caron Gray
Mélanie Lévesque
Shari Kastner
Billy Knight
Mitch Potrykus
Melissa Staude

Cover Photo

The cover photo was taken in Ireland by Rick Bate. I added two filters to the left and right portions of the image to highlight Photoshop's editing capabilities. The section on the left features Photoshop's Oil Paint filter, and the section on the right features the Patchwork filter. The center section is Rick's photo.

© 2019 by David Bate

ISBN: 978-0-9882405-3-7
Printed in U.S.A.

Speaking Photoshop Workbook

This workbook is meant to be used in conjunction with *Speaking Photoshop CC* (ISBN 978-0-9882405-2-0). It provides real world projects and questions designed to solidify the skills introduced in each chapter of the textbook. It is ideal for high school, college or university courses, or for those seeking to excel in and master the complexities of Photoshop.

Educational Resource Package

Any teacher who uses the *Speaking Photoshop CC Workbook* may also receive, at no charge, an *Educational Resource Package* containing PDF files of answer keys, grading rubrics, a midterm exam, and a final exam.

PDFs of chapter questions are also included, with instructions teaching students how to place chapter questions into Adobe InDesign to type their answers.

To obtain a copy of the Educational Resource Package, please send a written request on school letterhead to:

> Speaking Photoshop
> Educational Resource Package
> 18745 Ridgewood Lane
> Brookfield, WI 53045

Please be sure to include your email address. Educational Resource Packages are distributed via email.

Chapter Files

All of the files used in the book and workbook are available for download at *www.SpeakingPhotoshop.com*. They are intended for use with *Speaking Photoshop* or *Speaking Photoshop Workbook* only. Please do not use the files for other purposes or distribute them in any way. Copyrights remain with the author or the original photographers/artists.

◀ An Overview of Bridge and Photoshop ▶

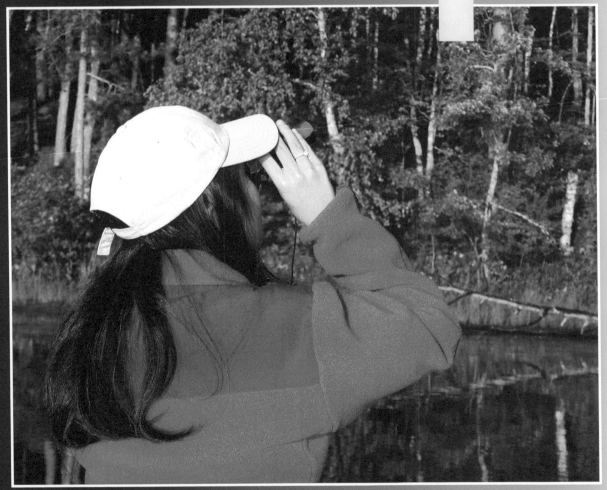

Dave Bate

► CHAPTER 1 QUESTIONS

1. What is the keyboard shortcut to open Bridge from Photoshop?

 option command O [handwritten]

2. What is the purpose of the Favorites panel, and how do you add items to it?

 Prioritizing images. [handwritten] *click 1-5 stars or Command 1-5* [handwritten]

3. Describe three ways to resize thumbnails.

4. How do you display a certain image as the thumbnail shown on a collapsed stack?

5. How do you rename labels?

6. Describe two ways to assign ratings without using the main menu.

7. Describe the process to link a keyword to an image.

8. I have keywords assigned to Craig and Daisy. How would I display images that contain either of them while hiding the others?

9. How do you collapse a panel in Photoshop?

10. What is the difference between the Rotate View Tool and Image>Image Rotation?

▶ CHAPTER 1 PROJECTS

Project 1A, Managing Images with Adobe Bridge

Complete the instructions below. Take a screen shot of your results for each step, print it out and label it with the step number. The example above shows the proper Bridge settings for step one.

1. Display all wedding images that have a rating of three stars or better.

2. Sort images in ascending order by label.

3. Show only images that have no label.

4. Create a keyword named *favorite*, assign it to five images, then display only those images.

5. Display only images that were taken at an f/8.0 aperture setting.

2

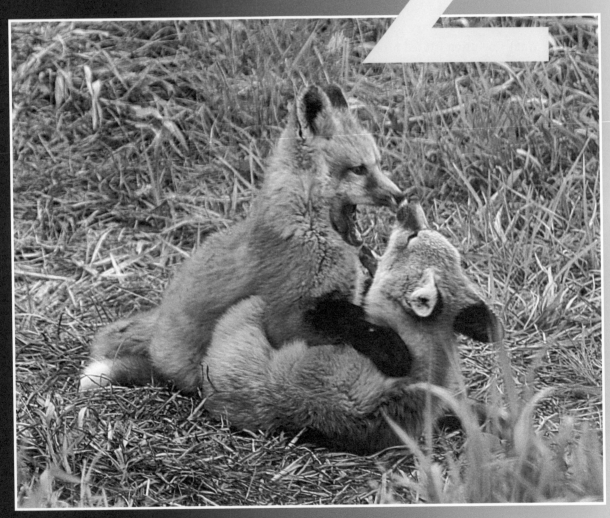

Caron Gray

► CHAPTER 2 QUESTIONS

1. Which unit of measure always has an effect on the file size in megabytes?

2. What's the purpose of the Resample Image check box in the Image Size dialog box?

3. What is the significance of an image's resolution?

4. What resolution is used for web images?

5. How is canvas size different from image size?

6. Explain the purpose of the Relative check box in the Canvas Size dialog box.

7. How do you adjust a crop bounding box and maintain a constant aspect ratio?

8. Explain how to straighten an image using the Crop tool.

9. List the six transform operations that Photoshop can perform.

10. What is the keyboard shortcut to distort an image when using Free Transform?

► CHAPTER 2 PROJECTS

Project 2A, Grand Tetons

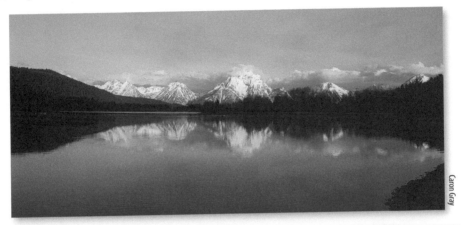

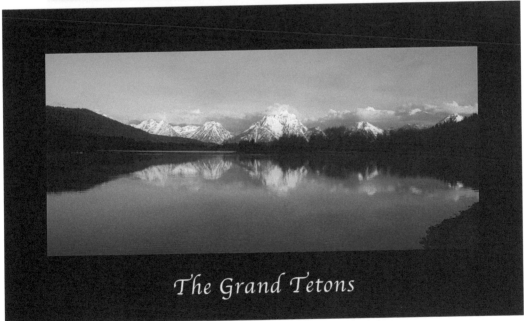

Follow the instructions in the book and add
"The Grand Tetons" in the matte area beneath the photo.

Project 2B, Sturgeon Bay

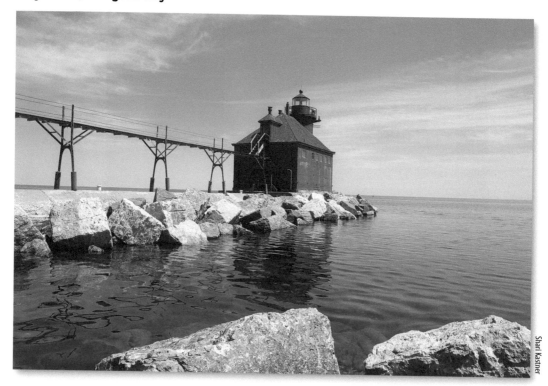

Open *Sturgeon Bay.jpg*, a photo taken by WCTC student Shari Kastner.
Crop and size the photo to match the samples and specifications below.

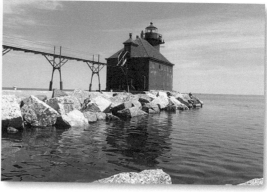

- 6" x 4.25"
- Resolution set for 150 line screen

- 600 x 400 pixels
- Resolution set for the web

Chapter 2: Resizing, Cropping and Transforming

Project 2C, Sunset

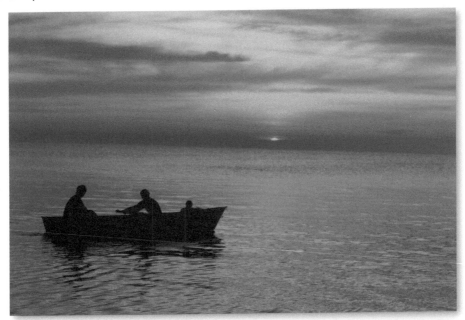

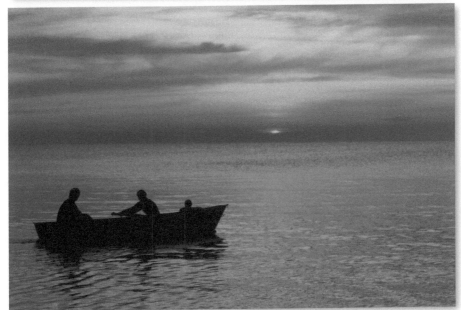

Use the Crop tool to straighten *Sunset.jpg*.

Project 2D, Pena Palace

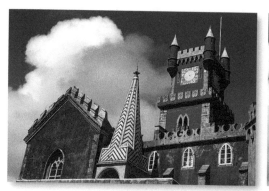 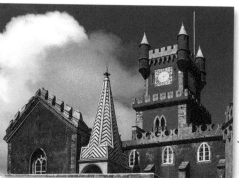

Phyllis Bankier

Use Distort to fix the keystoning in *Pena Palace.jpg*.

Project 2E, Holy Hill

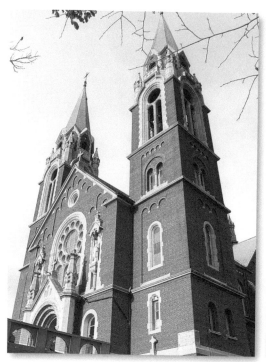 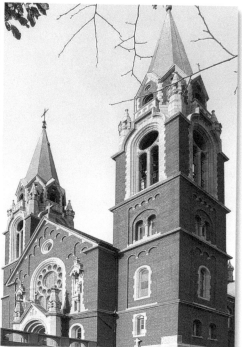

Correct the keystoning in *Holy Hill.jpg*.

3

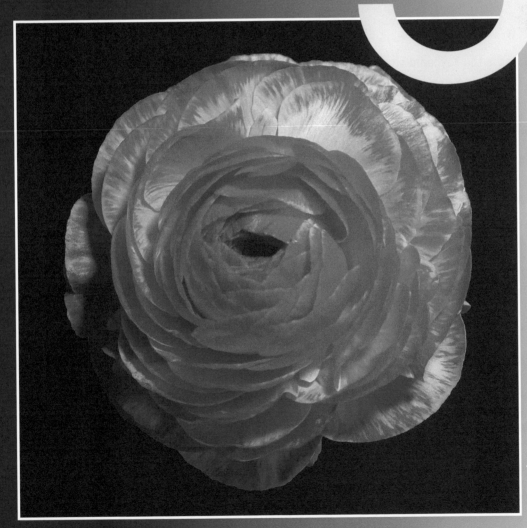

◄ *Creating Selections* ►

Phylis Bankler

1. How do you create a perfect square or circle as you create a marquee selection?

2. What is the keyboard shortcut to fill a selection with the foreground color?

3. What effect does feathering have on a selection?

4. What is the keyboard shortcut that subtracts from a selection?

5. Which selection tool snaps to edges as you drag around an image?

6. What two important factors affect the quality of an image placed into a new background?

7. Describe how to use the Quick Selection tool.

8. What type of images are best suited for the Magic Wand tool?

9. What is the purpose of Localized Color Clusters in the Color Range command?

10. What three attributes does a Layer Comp remember?

Project 3A, Buttercups

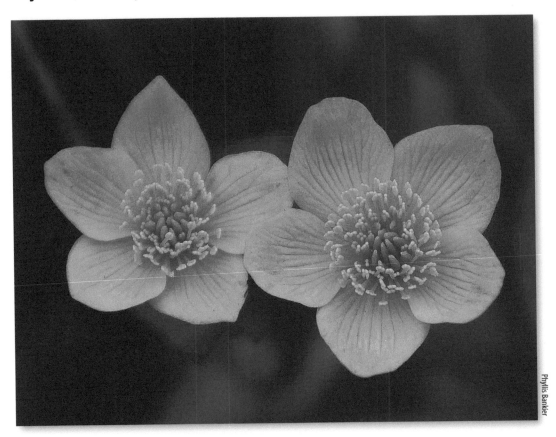

Phyllis Bankier

Follow the instructions in the book and complete the following.

1. Select the buttercups using the Magnetic Lasso tool, the Quick Selection tool, the Magic Wand and Color Range.

2. Copy each selection onto its own layer, and name the layer with the selection method used.

3. Choose your best result and modify the selection further to achieve a natural look when the buttercups appear above a white background.

4. Create a Layer Comp that shows each selection method above the white background.

Project 3B, Objects Galore

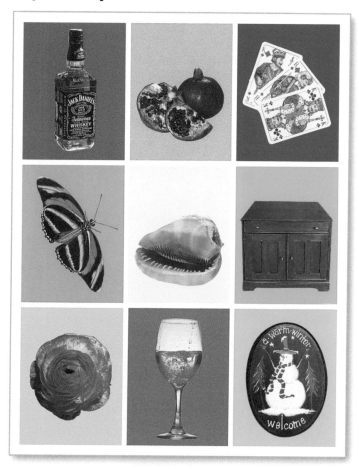

Photos
Shari Kastner: Whisky, Seashells.
Phyllis Bankier: Pomegranates,
Butterfly, Ranunculus, Wine Glass.
Dave Bate: Cards, Chest, Snowman.

1. Create a new document, 8.25" wide by 10.5" high,
 300 pixels/inch, RGB mode, white background.

2. Choose View>New Guide and create guidelines at the
 following coordinates.
 Vertical: .25, 2.75, 2.875, 5.375, 5.5 and 8 inches.
 Horizontal: .25, 3.5, 3.625, 6.875, 7 and 10.25 inches.

3. Use the Rectangular Marquee to select and fill
 individual squares for a checkerboard effect. Use any
 color other than white or black.

4. Use Bridge to locate the photos in the sample.

5. Block out, scale and transform each picture as shown.

6. Add your name to the bottom right corner.

Chapter 3: Creating Selections

◄ *Levels, Curves, Shadows/Highlights* ►

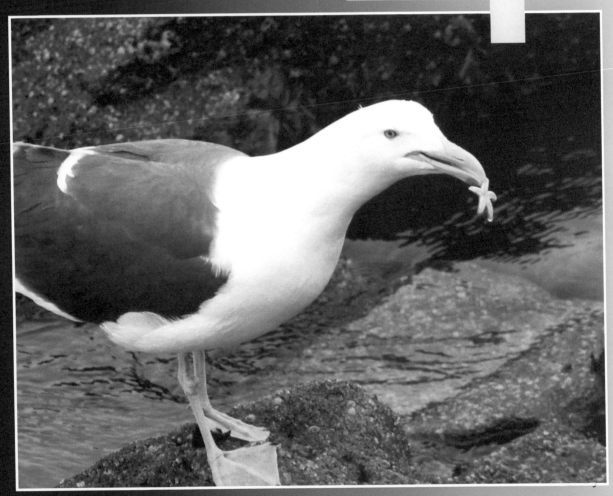

▸ CHAPTER 4 QUESTIONS

1. What is the purpose of the *Window>Arrange>Match All* command?

2. What is a histogram?

3. What is the negative side effect of clipping?

4. What are two advantages of using Adjustment layers?

5. Why do auto adjustments sometimes fail?

6. Describe the normal procedure for making a manual levels adjustment.

7. How do you adjust just part of an image?

8. What is the major advantage of Curves over Levels?

9. Why would you want to avoid a horizontal slope in a curve?

10. What is the purpose of Shadows/Highlights?

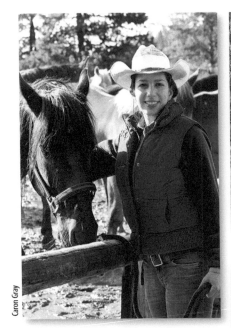

Caron Gray

Project 4A, Girl and Horse

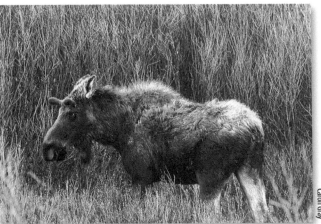

Caron Gray

Project 4C, Moose

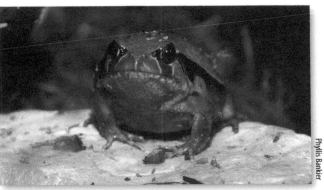

Phyllis Bankier

Project 4D, Toad

Open the photos above, duplicate them four times and perform the following adjustments on each image.

- Auto Levels
- Manual Levels
- Curves
- Shadows/Highlights

Be sure to use only nondestructive editing techniques and make good use of layer masks where appropriate. Append the adjustment technique to the file name, for example *Girl and Horse Auto Levels.psd*.

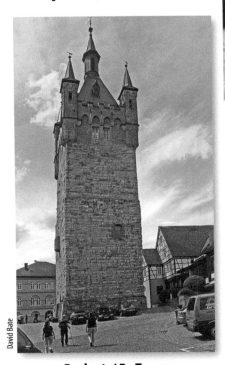

David Bate

Project 4B, Tower

5

◄ *A Color Balancing Act* ►

▶ CHAPTER 5 QUESTIONS

1. What are the additive colors and what color do they create when blended together?

2. What are the subtractive colors and what color do they create when blended together?

3. What is the significance of the formula R = G = B?

4. Define hue, saturation and brightness and explain how they relate to the color wheel.

5. Explain the meaning of color gamut. Which mode has a larger gamut, RGB or CMYK?

6. Describe how RGB histograms should look for a well balanced, typical image.

7. What tone range should you always correct first when using Color Balance?

8. Describe how to balance color using a manual levels adjustment technique.

9. Describe how to balance color using a Gray Point Eyedropper.

10. Describe how to balance color using Input/Output values in curves.

▶ CHAPTER 5 PROJECTS

Project 5A, Couple

Project 5B, Toddler

Duplicate these images and name them:

- Color Balance
- Manual Levels
- Eyedropper

Then perform the appropriate color adjustment technique on each image.

Place two sample points on each image, then color correct them using Input/Output values in Curves.

Project 5C, Race Car 1

Project 5D, Race Car 2

Project 5E, Race Car 3

6

◂ *Retouching* ▸

Mitch Potrykus

1. Describe the procedure to create a gradient.

2. How do you create your own gradient preset?

3. What is the purpose of the Smoothing function in the Brushes Options bar?

4. How can you draw a straight line at a 15° angle?

5. How do you remove red eye?

6. What is the purpose of *Aligned* in the Clone Stamp tool Options bar?

7. How do you set a source point using the Healing Brush tool?

8. What does the Content Aware option do for the Spot Healing brush?

9. Describe the steps for using the Patch tool.

10. Describe how to brighten teeth using a Hue/Saturation Adjustment layer.

► CHAPTER 6 PROJECTS

Terry Rydberg

Project 6A, Brush Art

Create a 7.5" x 10" document at 300 ppi.

Use the following techniques to create your artwork:

1. Five or more brush styles from the brushes Panel, i.e. brush tips, shape dynamics, scattering, etc.

2. Put each brush style on its own layer and name the layer for the technique used (i.e. "Scatter Brush").

3. Use two different style Gradient Blends, each on its own layer and named appropriately.

4. Change the layer blending mode on at least one layer of your choice.

5. Create a frame for the outside edge.

Project 6B, Girl

Use the retouching tools to complete the following:

1. Remove the red eye.

2. Remove all skin blemishes

3. Remove her necklace.

4. Brighten her teeth.

Shari Kastner

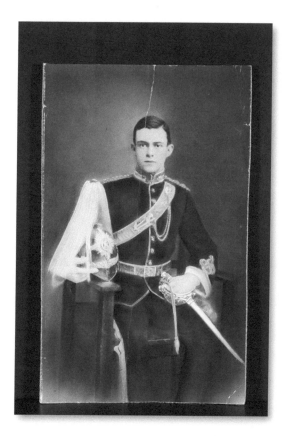

Project 6C, Dragoon

1. Crop the image to remove the black matte.

2. Repair all cracks and imperfections.

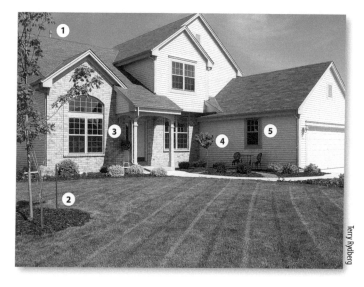

Project 6D, House

1. Remove the exhaust pipe from the roof.

2. Remove the stakes and ropes from the tree and add more leaves.

3. Lighten and saturate the flowers in the planter.

4. Add leaves to the ornamental tree.

5. Remove the glare from the garage window.

Terry Rydberg

7

▶ CHAPTER 7 QUESTIONS

1. List three ways that a Background layer differs from a Regular layer.

2. List three things you can do with a Regular layer that you can't with the Background.

3. How do you change the checkerboard pattern that indicates transparency?

4. Explain the difference between Opacity and Fill.

5. Name four ways you can lock a layer.

6. What is the purpose of the effects check boxes in the Layer Style dialog box?

7. How do you edit a layer effect that has already been applied?

8. How do you hide or reveal pixels using a layer mask?

9. How do you view a layer mask by itself?

10. Explain how to create a clipping mask.

Create simple grayscale artwork and transform it into an appealing composition using layer effects.

- Use a minimum of four layers (plus Background).
- All color must be added through layer effects.
- If the visibility for the effects is turned off, the artwork should be black, white or gray only.

Project 7A, Layer Effects

Follow the instructions in the book to place *Car.jpg* onto *Field.jpg*.

Project 7B, Car

7-4

Use the photos in the Collage folder to create a seamless composition.

1. Choose one image to be your central image.

2. Copy the other 4 images onto your central image.

3. Position and resize them as desired.

4. Use layer masks to create a seamless look. Paint with a large, fuzzy brush to blend the edges.

Project 7C, Collage

Use clipping masks and follow the instructions in the book to create a total of five illustrated words on an 8½" x 11" document. Each word should contain an image that describes it.

Project 7D, Illustrated Words

8

‹ Smart Objects, Filters & Vanishing Point ›

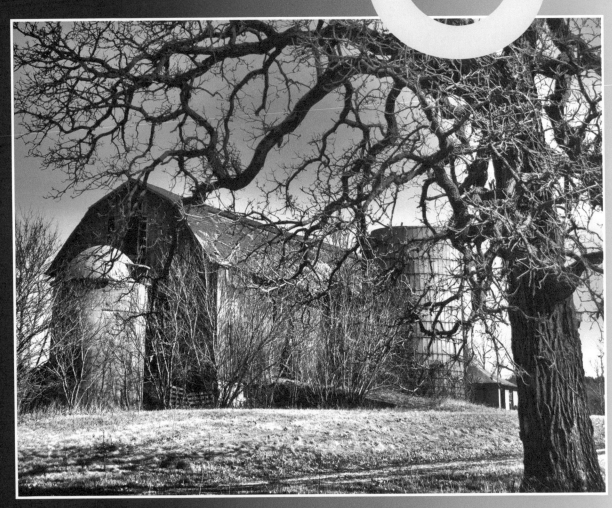

Billy Knight

► CHAPTER 8 QUESTIONS

1. Name three benefits of Smart Objects.

2. In one sentence, why can a Smart Object do all of the things it does?

3. Name three ways to import an Illustrator file as a Smart Object in Photoshop.

4. Describe two ways to duplicate a Smart Object.

5. You edited your Smart Object, but it didn't update. How could this have happened?

6. How do you apply a filter nondestructively to just part of an image?

7. What are two side effects of over sharpening?

8. What file format must a displacement map be in?

9. Describe how to create a perspective plane in Vanishing Point.

10. How do you bring type into Vanishing Point?

Rick Bate

Project 8A, Vanishing Point

Open *Building.jpg* and follow the instructions in the book to remodel Kate's Kafe.

► CHAPTER 8 PROJECTS

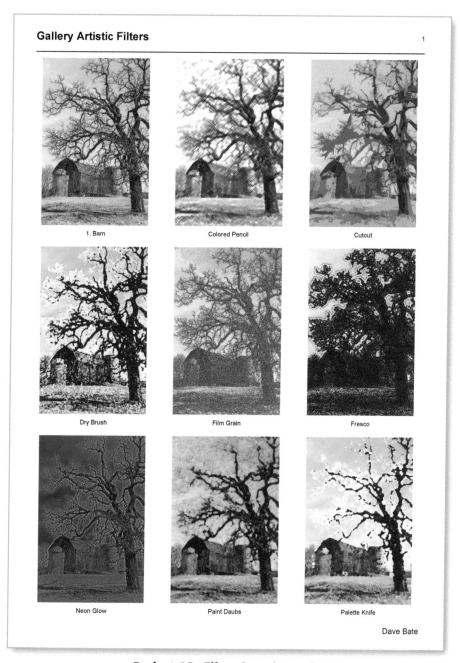

Gallery Artistic Filters 1

1. Barn Colored Pencil Cutout

Dry Brush Film Grain Fresco

Neon Glow Paint Daubs Palette Knife

Dave Bate

Project 8B, Filter Sample Book

Create a Filter Sample Book displaying all of the filters listed on the next page. Print the book using the contact sheet function in Bridge according to the following instructions.

Photoshop CC Gallery Filters

Gallery Artistic (15)
Colored Pencil
Cutout
Dry Brush
Film Grain
Fresco
Neon Glow
Paint Daubs
Palette Knife
Plastic Wrap
Poster Edges
Rough Pastels
Smudge Stick
Sponge
Underpainting
Watercolor

Gallery Brush Strokes (8)
Accented Edges
Angled Strokes
Crosshatch
Dark Strokes
Ink Outlines
Spatter
Sprayed Strokes
Sumi-e

Gallery Distort (3)
Diffuse Glow
Glass
Ocean Ripple

Gallery Sketch (14)
Bas Relief
Chalk & Charcoal
Charcoal
Chrome
Conté Crayon
Graphic Pen
Halftone Pattern
Note Paper
Photocopy
Plaster
Reticulation
Stamp
Torn Edges
Water Paper

Gallery Stylize (1) & Gallery Texture (6)
Glowing Edges
Craquelure
Grain
Mosaic Tiles
Patchwork
Stained Glass
Texturizer

Additional Photoshop CC Filters

Blur (11)
Average
Blur
Blur More
Box Blur
Gaussian Blur
Lens Blur
Motion Blur
Radial Blur
Shape Blur
Smart Blur
Surface Blur

Blur Gallery (5)
Field Blur
Iris Blur
Tilt-Shift
Path Blur
Spin Blur

Distort (9)
Displace
Pinch
Polar Coordinates
Ripple
Shear
Spherize
Twirl
Wave
ZigZag

Noise (5)
Add Noise
Despeckle
Dust & Scratches
Median
Reduce Noise

Pixelate (7)
Color Halftone
Crystallize
Facet

Fragment
Mezzotint
Mosaic
Pointillize

Render (8)
Flame
Picture Frame
Tree
Clouds
Difference Clouds
Fibers
Lens Flare
Lighting Effects

Sharpen (6)
Shake Reduction
Sharpen
Sharpen Edges
Sharpen More
Smart Sharpen
Unsharp Mask

Stylize (9)
Diffuse
Emboss
Extrude
Find Edges
Oil Paint
Solarize
Tiles
Trace Contour
Wind

Other (6)
Custom
High Pass
HSB/HSL
Maximum
Minimum
Offset

Run the Filters and Save the Files

The purpose of this exercise is to explore Photoshop's many filters and print a resource booklet that you can refer to for years to come. Don't just accept the default settings as you work with the filters. Experiment with different options and choose a setting that looks attractive to you. Bridge's contact sheet function makes printing the booklet easy, but the files have to be saved in separate folders in order for that to work smoothly. Use the instructions below to create and save your filter files.

1. Create a folder for each filter category: *Gallery Artistic, Gallery Brush Strokes,* etc. You will be printing one contact sheet per folder.

2. Copy *1 Barn.jpg* into each folder. This will place the original, unfiltered file at the top left of each filter category for comparison purposes. The file name starts with a numeral to place it at the top of the order alphabetically.

3. Open *1 Barn.jpg* in Photoshop and convert it to a Smart Object. This allows you to check and/or change your settings in the future. Some of the filters are not compatible with Smart Objects. Choose *Flatten Image* from the Layers panel to run those.

4. *Choose Image>Duplicate* and name the file for the filter you are going to use, i.e. *Colored Pencil, Cutout,* etc. The file names will also serve as captions in the contact sheet, so type carefully.

5. Run the filter and save the file into the folder named for that filter category. For example, save the *Colored Pencil* file in the *Gallery Artistic* folder.

6. When all of the files in a category have been saved, you are ready to create a contact sheet using Bridge.

Create Contact Sheets in Bridge

Open Bridge and navigate to one of the filter category folders. Make sure that *Sort by Filename* and *Ascending Order* is selected in the Options bar. This will place *1 Barn.jpg* at the top of the list, followed by each of your filter files in alphabetic order, like they appear in the menus (in most cases).

Choose *Window>Workspace>Output* to open the Output panel. A large Canvas area appears representing your page size, and beneath that is a Content tab containing available files. Type *Command+A/Control+A* to select the files, then drag them onto the Canvas area. Now work your way down the Output panel and choose the options shown on the next page.

Contact Sheet Settings

1
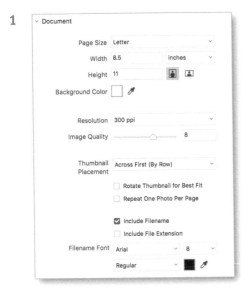

Specify page size, background color, print quality and thumbnail placement. Check *Include Filename* and specify the filename font.

2
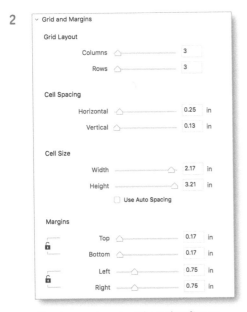

Use columns and rows to set the number of images. Cell spacing, size and margins affect image placement.

3
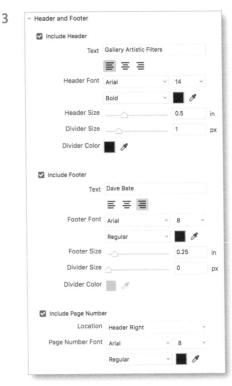

The Header and Footer panel lets you add text above and below the image thumbnails. The page number section adds automatic page numbers.

4

Click *Export to PDF* to create the final PDF file. Open it in Adobe Acrobat and print it.

5
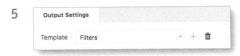

When you are done, you can save your settings in a template for future use. Click on the plus sign and give it a name.

Chapter 8: Smart Objects, Filters & Vanishing Point

‹ *Distort, Warp & Content Aware* ›

► CHAPTER 9 QUESTIONS

1. How do you work nondestructively with the Liquify filter?

2. What is the purpose of the Freeze Mask tool?

3. How can you edit an image that you previously liquified?

4. Name two things you should do before using Puppet Warp on an image.

5. Where should adjustment pins be added in Puppet Warp?

6. Why might you want to change the pin depth in Puppet Warp?

7. How does Content Aware Fill work?

8. How does Content Aware Scale know which portions of an image to scale?

9. What is an Alpha channel?

10. How do you use the Content Aware Move tool to extend an image?

► CHAPTER 9 PROJECTS

Project 9A, Billboards

You have created three billboard layouts for your client. In addition to the flat artwork, you want to show them how the billboards will look in the locations you have planned for them. Use Free Transform and *Command+Drag/ Control+Drag* the corner handles to take the billboard artwork samples and place them onto the three billboard photos. Be sure to make the perspective of the artwork match the perspective of the respective signs. In addition to placing the billboard artwork onto the signs, complete the image enhancement techniques as described below.

Adding sky between the branches

Using a layer mask to keep the sky from overlapping the billboards and foreground is easy, but it's not practical to create a mask around all of the tree branches. Instead, try applying different layer blending modes to the sky layer.

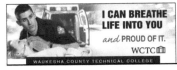
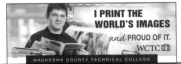
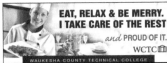

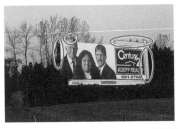
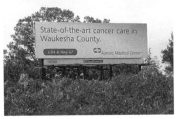
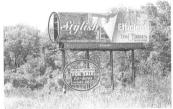

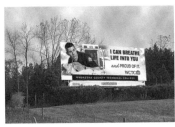
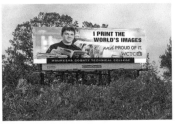
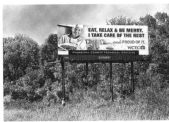

Billboard One	**Billboard Two**	**Billboard Three**

Billboard One

- Use a Levels or Curves adjustment layer to adjust the luminosity.
- Use a Vibrance adjustment layer to add more color to the foreground.
- Use the Clouds filter with a layer mask to create a pretty sky.
- Remove the Century 21 sign post, the top of the man's head, and the back edge of the billboard along the left side.

Billboard Two

- Use a Levels or Curves adjustment layer to adjust the luminosity.
- Use a Vibrance adjustment layer to add more color to the foreground.
- Use the Clouds filter with a layer mask to create a pretty sky.

Billboard Three

- Use a Levels or Curves adjustment layer to adjust the luminosity.
- Use a Vibrance adjustment layer to add more color to the foreground.
- Use the Clouds filter with a layer mask to create a pretty sky.
- Remove the For Sale sign and the back edge of the billboard along the left side.

9-4

► CHAPTER 9 PROJECTS

Project 9B, Caricature

Find a photo of yourself, or a friend with a good sense of humor, and create a caricature using Liquify. Use at least three different Liquify tools.

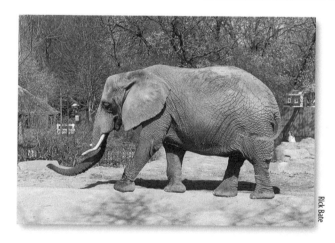

Rick Bate

Project 9C, Puppet Warp

Following the instructions in the book, use Puppet Warp to place the elephant in a new pose.

Phyllis Bankier

Project 9D, Content Aware

Follow the instructions in the book and create comparative layers for Normal Scale, Content Aware Scale, Skin Protect, Alpha Protect, and Content Aware Move.

Chapter 9: Distort, Warp & Content Aware

10

‹ *Camera Raw, Photomerge & HDR* ›

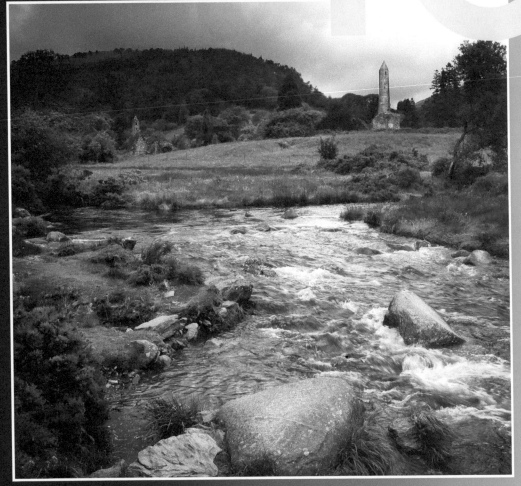

Rick Bate

▶ CHAPTER 10 QUESTIONS

1. Name two advantages of capturing images using Camera Raw.

2. Name three ways to correct white balance.

3. How can you apply Camera Raw settings to multiple images?

4. What is the purpose of an XMP file?

5. Your Tone Control settings do not include Highlights. Why might this be?

6. What is the Adjustment Brush and how does it work?

7. How do you change a cropped area that has already been applied to a raw file?

8. Describe how to retouch using the Spot Removal tool.

9. Describe how to create a panorama using Photomerge.

10. What are three important considerations when taking photos for *Merge to HDR Pro*?

▶ CHAPTER 10 PROJECTS

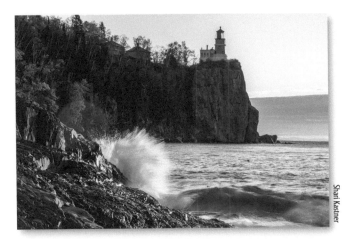

Shari Kastner

Project 10A, Lighthouse Cliff

Following the instructions in the book, use Camera Raw to enhance the detail and color of *Lighthouse Cliff.NEF*. Be sure to keep the XMP file with the raw file, or the settings will be lost.

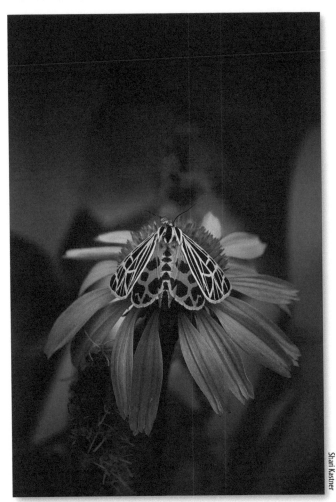

Shari Kastner

Project 10B, Butterfly

Follow the instructions in the book to brighten the butterfly and darken the surroundings.

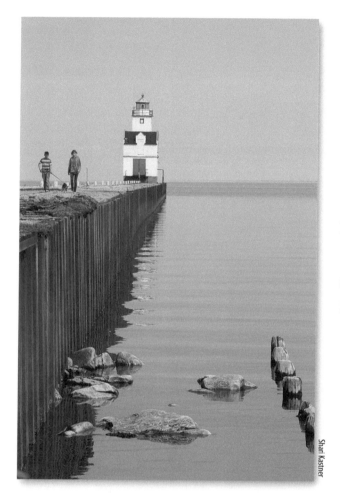

Shari Kastner

Project 10C, Another Lighthouse

Follow the instructions in the book and use Camera Raw to do the following:

1. Straighten the image.

2. Crop for a 4" x 6" print.

3. Remove the blemishes from the lighthouse.

Shari Kastner

Project 10D, Sunset on Lake

Open *Sunset on Lake.NEF* in Camera Raw and do the following:

1. Adjust the White Balance.

2. Adjust the Tone Settings.

3. Remove the dark spots in the sky (seagulls).

The final image should be void of seagulls and have improved detail and color.

Project 10E, Photomerge

Use Photomerge to create a panorama of WCTC's campus. Crop the image to remove transparent wedges and correct the verticals.

Project 10F, HDR Porch

Use *Merge to HDR Pro* to create a high dynamic range image using the photos contained in the Porch HDR folder.

◄ *Extracting Images—A Hairy Proposition* ►

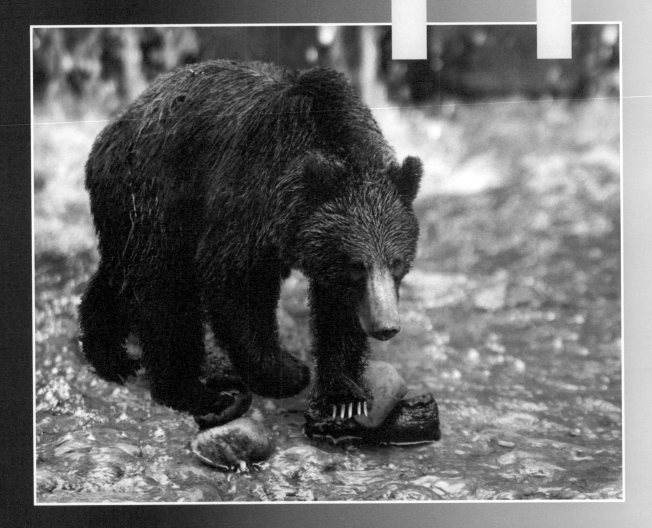

► CHAPTER 11 QUESTIONS

1. How do you center-align two images when you drag-copy one to the other?

2. How do you disable a mask temporarily so you see the original image?

3. How do you view a layer mask by itself?

4. How can you make hair look more natural when manually working on the mask?

5. What are fringe pixels and how do you eliminate them?

6. Why is it important to view your image on its final background in Select and Mask?

7. What is the purpose of the radius region in Select and Mask?

8. What method lets you define a radius and gives you complete control over its width?

9. How do you remove fringe pixels that are too bright?

10. How can you match the color palette of the extracted image to its new background?

Shari Kastner

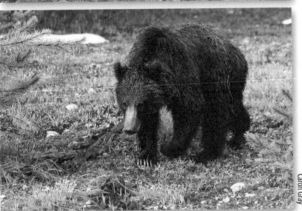

Caron Gray

Project 11A, Bear

Open *Bear Stream.jpg* and *Bear.jpg*. Following the instructions in the book, use manual masking techniques to place the bear in the stream. Eliminate fringe pixels and clone missing parts of the bear as necessary.

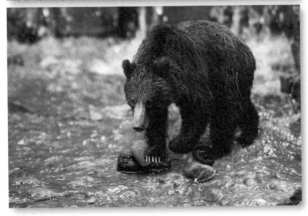

Shari Kastner

Project 11B, Dina

Open *Dina's Sunset.jpg* and *Dina.jpg*. Use Select and Mask to place Dina into the sunset image. Correct color fringe, white balance and exposure according to the instructions in the book.

Rick Bate

Project 11C, Orangutan

Open *Orangutan.jpg*. Fix the light reflection using Content Aware Fill or other retouching methods. Place the orangutan on a white background.

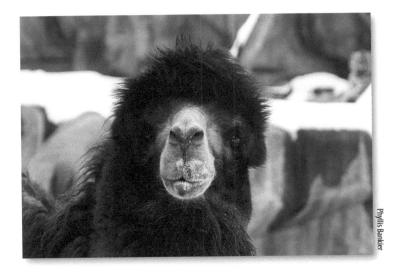

Phyllis Bankier

Project 11D, Camel

Open *Camel.jpg*. Extract it and place it on a red background made up of 100R, 10G and 10B.

12

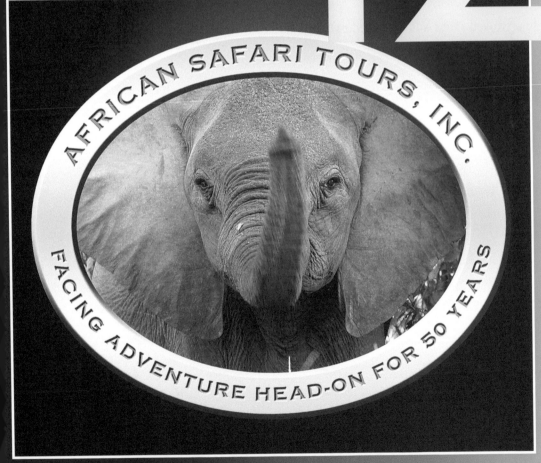

AFRICAN SAFARI TOURS, INC.

FACING ADVENTURE HEAD-ON FOR 50 YEARS

Melissa Staude

► CHAPTER 12 QUESTIONS

1. Why does vector art scale better than raster art?

2. Name one benefit of using raster art.

3. What is the difference between the Path Selection tool and the Direct Selection tool?

4. How do a stroked *shape* and a stroked *path* react differently when you edit its shape?

5. How do you stroke a shape with a dotted line?

6. Why does the Align Edges option result in a crisper looking rectangle shape?

7. What is the purpose of the Auto Add/Delete option in the Pen tool Options bar?

8. How do you move points or directional handles while creating a path with the Pen tool?

9. How do you create a selection from a path?

10. What is the difference between Point type and Paragraph type?

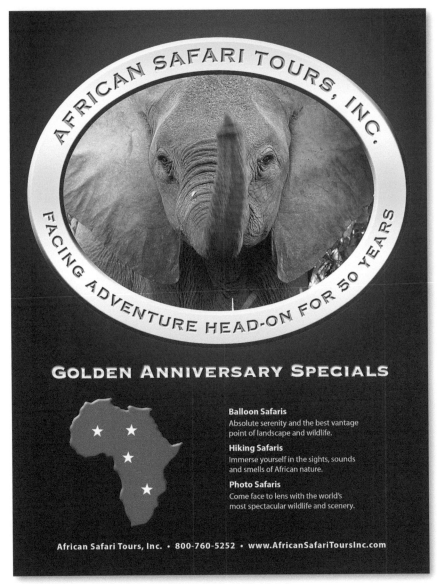

Project 12A, Safari Ad

Follow the instructions in the book and recreate the Safari ad.

► CHAPTER 12 PROJECTS

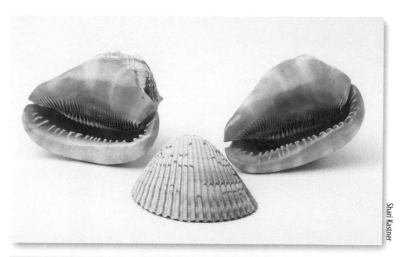

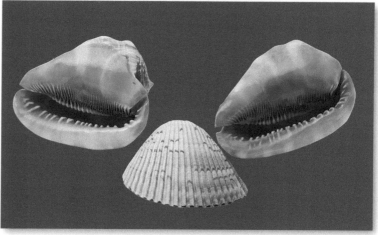

Shari Kastner

Project 12B, Sea Shells

Place the sea shells on top of a new background using the following procedure.

1. Open *Sea Shells.jpg*.
2. Create a path around the shells with the Pen tool.
3. Convert the Background layer into a Regular layer.
4. Add a new Color Fill layer beneath the Sea Shells layer.
5. Use the path to add a Vector Mask to the Sea Shells layer.

13

◄ Output for Print & Web ►

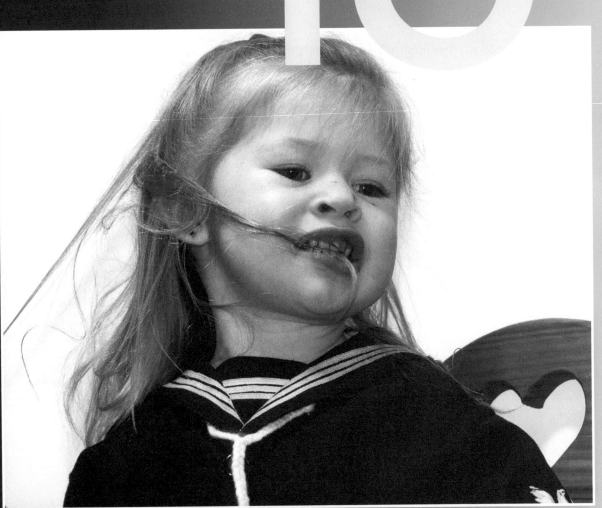

Bill Elliott

▶ CHAPTER 13 QUESTIONS

1. How do you access your printer driver software from Photoshop's print dialog box?

2. What is the purpose of *Scale to Fit Media*?

3. Which color space has a larger gamut, RGB or CMYK?

4. How do you synchronize your color settings throughout the Creative Suite?

5. The Image>Mode>Duotone command is grayed out. Why might this be?

6. How do you add a spot Pantone color to a Photoshop document?

7. Which file format(s) are best suited for line art on the Web?

8. Which file format(s) are best suited for photographs on the Web?

9. Describe the procedure for optimizing line art for the Web.

10. Describe the procedure for optimizing a photograph for the Web.

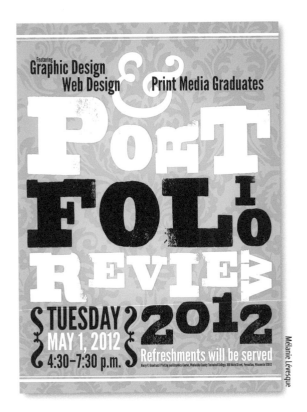

Project 13A, Portfolio Review Poster

Follow the instructions in the book and recreate the Portfolio Review poster using Black and Pantone 3105. Save the file as a PSD, so it color separates properly.

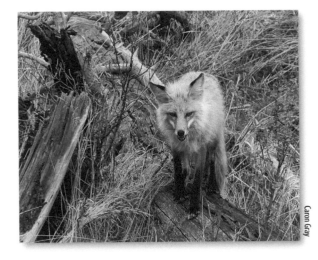

Project 13B, Duotone

Open *Fox.jpg*.

1. Convert the file into a Duotone. Choose Pantone colors that complement your design. One of the colors may be black.

2. Edit the curves in the Duotone dialog box to enhance the color.

3. Save the file in a file format that color separates properly.

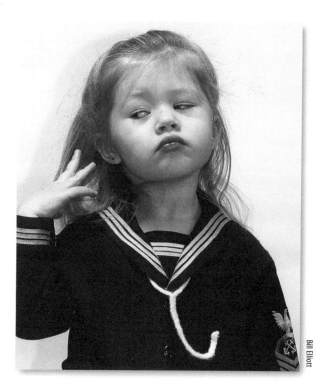

Bill Elliott

Project 13C, Navy Girl

Open *Navy Girl.jpg*.

1. Crop the image as shown on the left.

2. Use Photoshop's Save for Web to save the file for use on the internet.

3. The web master has asked you to save the image at 400 pixels wide, in as small a file size as possible, with no visual degradation in quality.

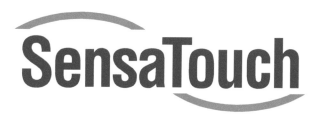

Project 13D, SensaTouch Logo

Open *SensaTouch Logo.ai*.

1. Use Photoshop's Save for Web to save the file for use on the internet.

2. The web master has asked you to save the logo at 200 pixels wide, with transparency enabled, in as small a file size as possible, with no visual degradation in quality.

Lightning Source UK Ltd.
Milton Keynes UK
UKHW051139260820
368832UK00004B/83